WORCESTER

HISTORY TOUR

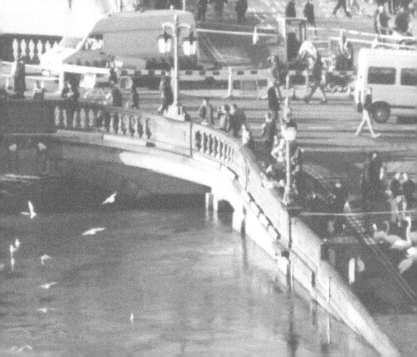

Map contains Ordnance Survey data © Crown copyright and database right [2014]

First published 2015

Amberley Publishing
The Hill, Stroud,
Gloucestershire, GL5 4EP
www.amberley-books.com

Copyright © Ray Jones, 2015

The right of Ray Jones to be identified
as the Author of this work has been
asserted in accordance with the
Copyrights, Designs and Patents Act
1988.

ISBN 978 1 4456 4647 3 (print)
ISBN 978 1 4456 4648 0 (ebook)

British Library Cataloguing in
Publication Data.
A catalogue record for this book is
available from the British Library.

Typesetting by Amberley Publishing.
Printed in Great Britain.

INTRODUCTION

Like all towns and cities Worcester is undergoing constant change. In a previous look at changing Worcester in 2001 I commented that 'endless debate ensues on whether or not such change is always desirable or necessary, but, despite never ending public enquiries and planning hurdles to be jumped, the landscape of our city seems to be changing beyond recognition.' Well, in fourteen years nothing much has changed and Worcester continues to change, almost beyond recognition in some parts of the city.

This change, however, has been reasonably positive in the main. Nearly all of us will welcome the redevelopment schemes taking place on large sites previously used by local historic industries: Diglis Water, The Waterside, and the Lowesmoor redevelopment scheme. All of these schemes have involved the preservation and refurbishment of important and historic buildings thus considerably enhancing the quality of the new Worcester urban environment.

Also to be welcomed are the new library and history centre in The Butts, known as the Hive, and the University campus development that has taken place on the old Royal Infirmary site.

Worcester is therefore taking the ambitious steps necessary in order to become a vibrant and dynamic city in the twenty-first century. However its future as a major tourist destination is still, in my view, somewhat in the balance. The loss of porcelain making at the Royal Worcester factory, ending over 250 years of continuous production, was not only a severe blow to the local economy but has, of course, also seen the end of the factory tours that brought many visitors to Worcester. Our world-class Worcester Porcelain Museum has thus

been left in a rather isolated position but hopefully the Waterside and Diglis Water projects can attract even more visitors to this historic part of Worcester. Worcester also continues to be blighted by traffic problems that deter day visitors in particular. Opportunities that have arisen to provide local rail links have been ignored because of envisaged cost, but at least a new Parkway railway link at Norton looks likely to be built at last. The grandiose park and ride schemes that I heavily criticised in *Worcester Through Time* in 2009 have recently been abandoned. I commented then, 'they clearly do not work, are not cost-effective, and blight areas on the rural urban fringe'. Is there any hope that the under-utilised bus lanes will also disappear as has recently happened in Liverpool? Radical thinking to address the traffic problems Worcester faces in the future is needed. Urban expansion needs to take place in the form of a new town with major transport infrastructure. To add further expansion to the rural surrounds of Worcester will merely exacerbate the existing gridlock. New developments also lack the necessary car-parking provision that they clearly need.

Worcester is now a city of around 100,000 inhabitants and further expansion is deemed necessary by national government. Obviously expansion could be achieved but this would be at a great cost. The remaining historic core of Worcester, once one of the principal cities in England, is in danger of being overwhelmed by the sheer volume of urban expansion. Worcester, constrained by its flood plain and history, has reached its optimum size.

There have been, however, several positive developments that have enhanced Worcester as a tourist centre. Chris Jaeger has admirably raised the profile of Worcester as an arts centre with his sterling efforts at the Swan Theatre and Countess of Huntingdon Hall. He also organises the annual Worcester Festival held in August that goes

from strength to strength. There is also the popular Christmas Fayre and a variety of guided walks and living history. The Commandery has also been revamped and an admirable band of volunteers make Tudor House in Friar Street an attraction for both tourists and local history buffs.

In conclusion Worcester is radically different from the city it was only a century ago. I personally think it could be a better place to live in and visit if government (both local and national) had shown greater foresight. But Worcester has probably fared no better or worse than countless other urban conglomerations of a similar size. The problem is really that Worcester should have fared far better than many other towns and cities because of its past historical significance.

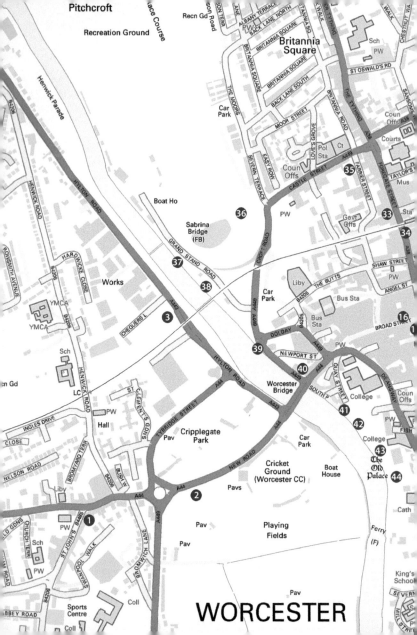

WORCESTER

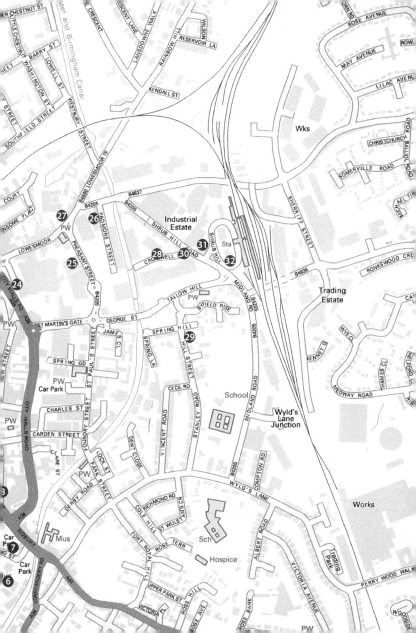

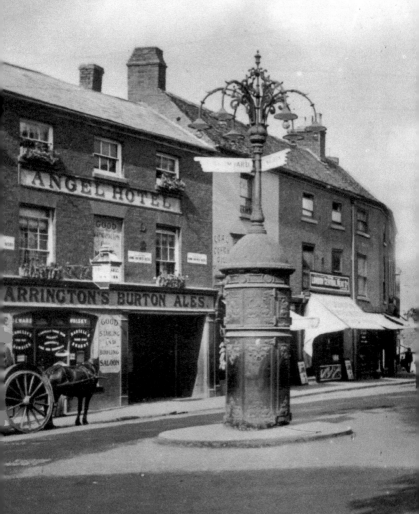

ST. IOBE

1. ST JOHN'S SHOPS

The old view dates from around 1916. Shops on the right include Robert Birch (grocer) and F. Bullock & Co. (cycle and motor works). The electric tram is roughly level with the entrance to the tram depot that was on the left (now the Co-op supermarket). Some older properties have been replaced but the modern view is quite similar apart from the background Bull Ring flats. The former Angel Hotel is now a carpet shop. The large sign adorning the building remains intact.

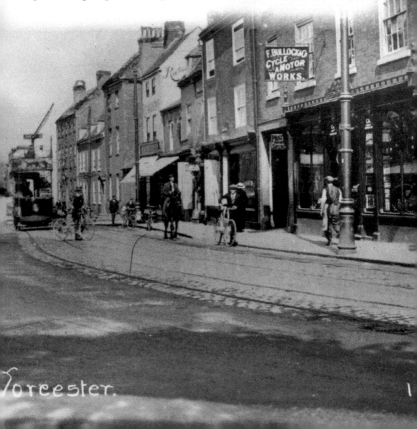

Worcester.

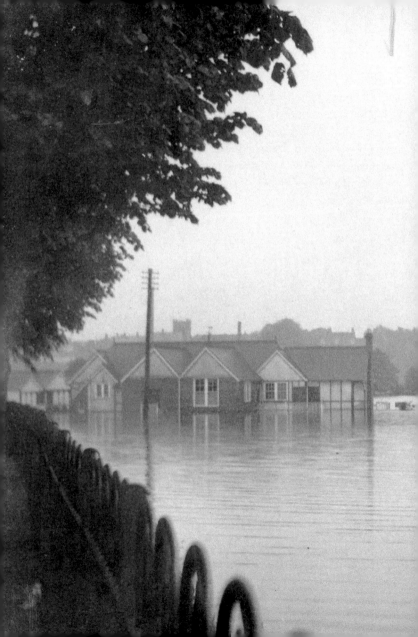

2. NEW ROAD FLOODS

Cricket at New Road was severely disrupted in June 1924 by a freakish flood that was 15 feet 9 inches above summer level. Unfortunately, a similar flood in June 2007 (approximately 15 feet 7 inches above summer level) caused havoc and resulted in substantial financial loss. Floods continue to be a major issue for the cricket club.

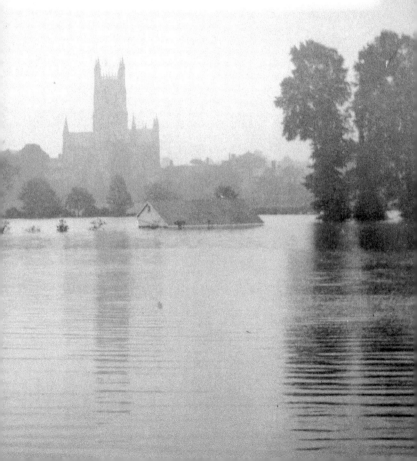

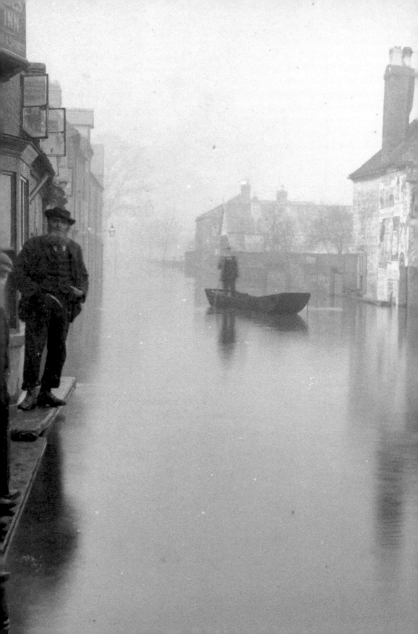

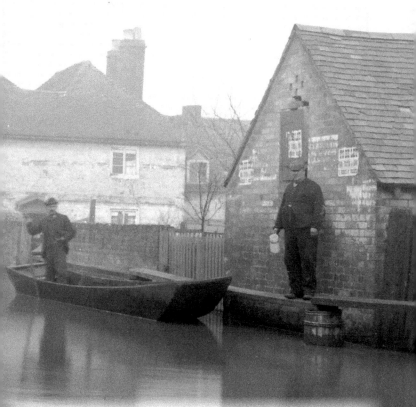

3. HYLTON ROAD IN FLOOD

On the extreme left of this old view (probably the flood of December 1900) is the Chequers Inn. The licensee was Joseph Yeates who was also a fruiterer (see page 81 of my book, *Pioneers of Photography in the City of Worcester & Around*). The view is looking northwards from near the junction with Chequers Lane.

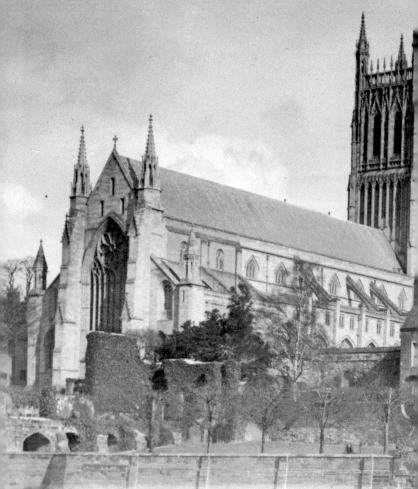

4. CATHEDRAL VIEW

This old postcard, probably by Clutterbuck, was franked in April 1912 and possibly features the flood of December 1910. The cathedral ferry can be seen in the foreground on the right, and it still operates today.

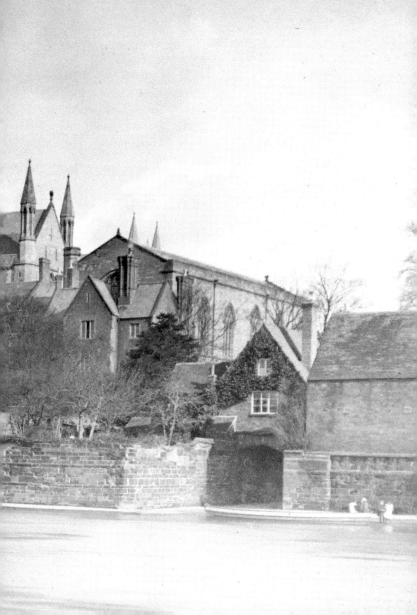

5. PORCELAIN WORKS

This rare view of the works dates from around 1908. The building on the right was built in 1879 and housed the original museum and the office of R. W. Binns, who ran the company, on the top floor. The recent demolition of various factory buildings revealed a similar view in September 2008. The Bone Mill can be seen in the distance.

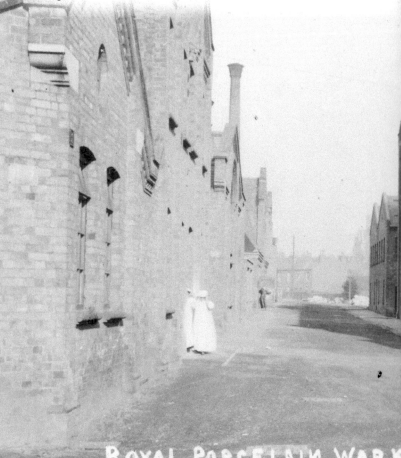

ROYAL PORCELAIN WORK

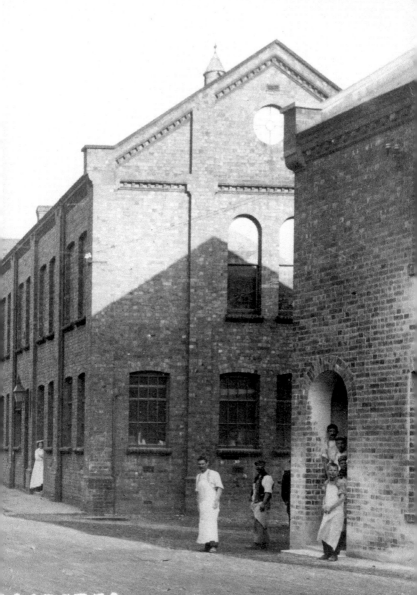

RCESTER. 1254

6. PORCELAIN WORKS AND ORIGINAL MUSEUM

The inset photograph is taken from a stereoscopic card (over 100 years old) and features the process of throwing. The man who works at the potter's wheel is called the thrower. He receives from his assistant a ball of clay that he throws upon the head of the wheel, or horizontal lathe, before him. He then moulds and fashions the clay accordingly. The Throwing House, designed by G. B. Ford and built in 1877, is now 5,472 square feet of high specification flexible office space. The Throwing House is close to the preserved Bone Mill.

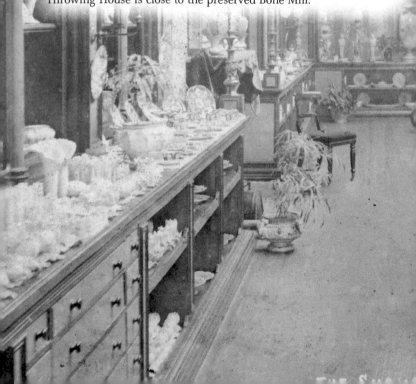

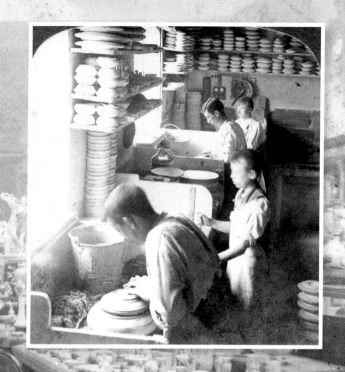

ROYAL PORCELAIN WORKS.

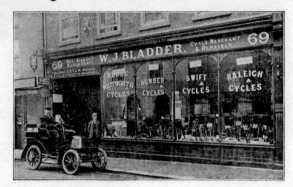

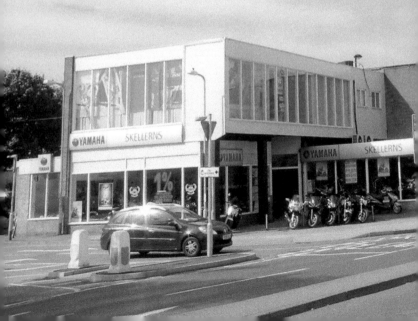

7. SIDBURY TRANSPORT DEALERS

W. J. Bladder was a well-known firm of cycle dealers in Sidbury. In 1908 they were the sole agents for Humbers, Swifts, and Raglans and were also manufacturers of the 'Worcester Road Cycles'. The premises, opposite the King's Head public house, were eventually knocked down in order to widen the Sidbury thoroughfare. Skellerns Motorcycles now occupy a similar location.

8. FRIAR STREET

The Victorian view of Friar Street shows a fairly busy scene. The building on the extreme right was once part of the old gaol that became the original Laslett's Almshouses in 1867. The current almshouses replaced the original ones in 1912. The modern provision for alfresco eating and drinking has produced a bustling locale.

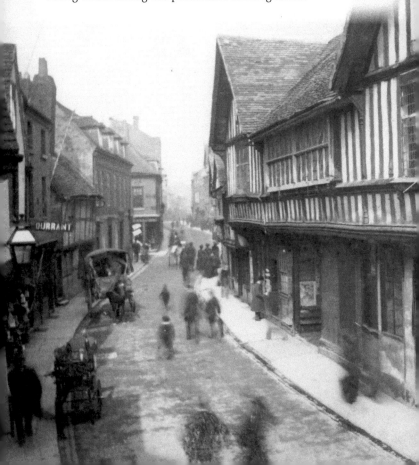

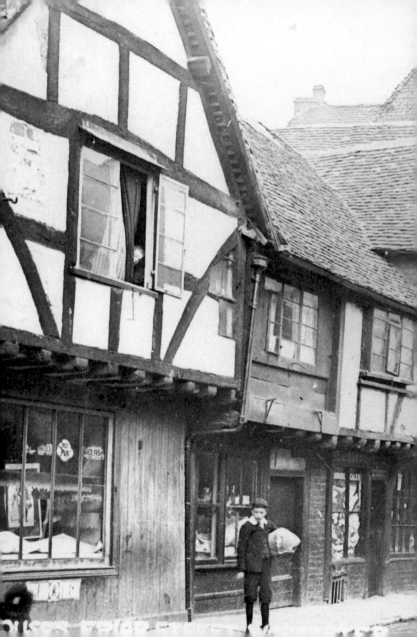

9. FRIAR STREET

Further down Friar Street there are no modern intrusions of note. The Laslett's Almshouses, now just over 100 years old, blend in well with their surroundings. Here there is a real sense of the historic Worcester. If only Lich Street had been preserved in a similar manner. The old postcard view was franked in 1905. The now missing building, just beyond the Crown Inn (no longer a public house), was a Wesleyan mission hall in Edwardian times. It was later used by Richard Cadbury as a Welcome Mission.

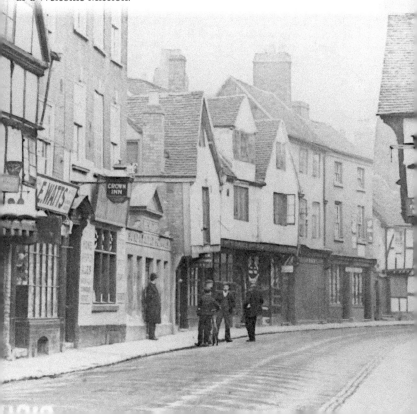

10. EAGLE VAULTS, FRIAR STREET AND PUMP STREET

The old photograph was taken in 1968. The Eagle Vaults has a magnificent tiled frontage that probably dates from the late Victorian period. Also of merit are the decorous sandblasted windows. The building itself is considerably older (probably late seventeenth century), and has been an inn for well over 200 years. In 1779 it was known as Young's Mug House and was also called the Volunteer between 1814 and 1817. After that it became the Plumbers Arms, before being given its current name around 1859.

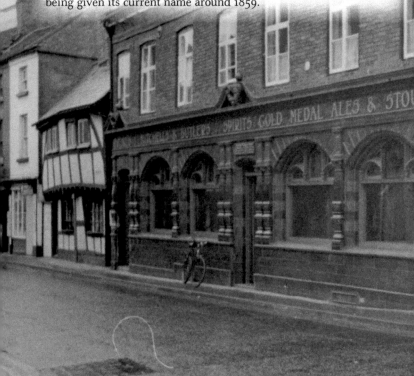

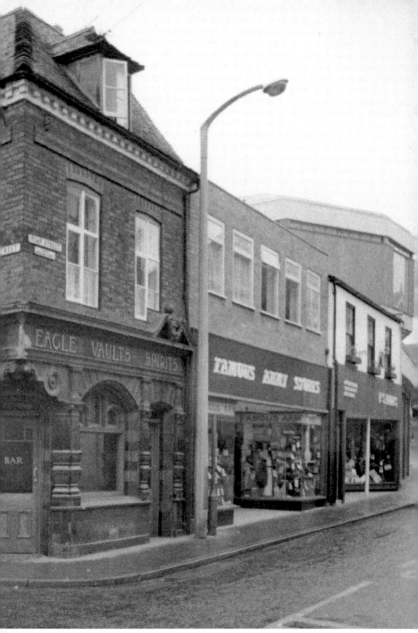

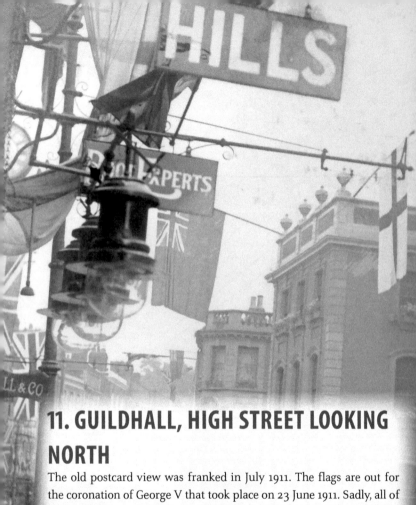

11. GUILDHALL, HIGH STREET LOOKING NORTH

The old postcard view was franked in July 1911. The flags are out for the coronation of George V that took place on 23 June 1911. Sadly, all of the old buildings beyond the Guildhall no longer exist. The Guildhall now enhances a rather disjointed high street scene, where historic façades compete with their modern counterparts and the inevitable intrusive trees.

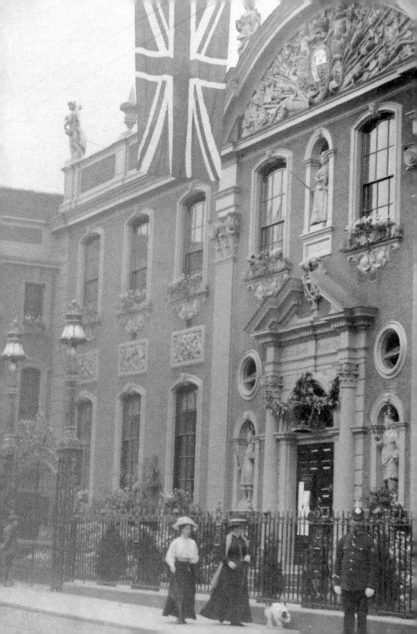

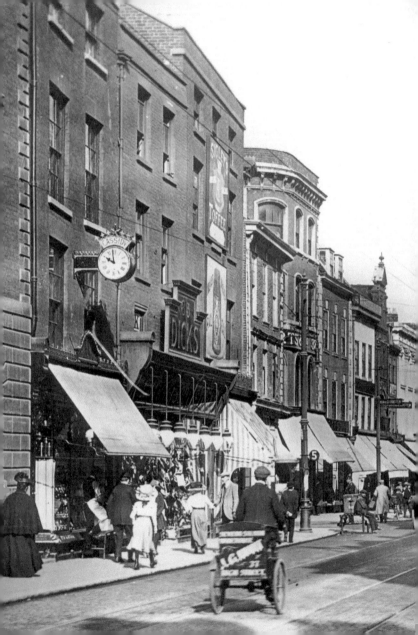

12. THE CROSS AND UPPER HIGH STREET

This postcard features a bustling scene of activity from the tram era. The pedal-powered cart belongs to Joseph George Hunt, a fishmonger based at No. 37 High Street.

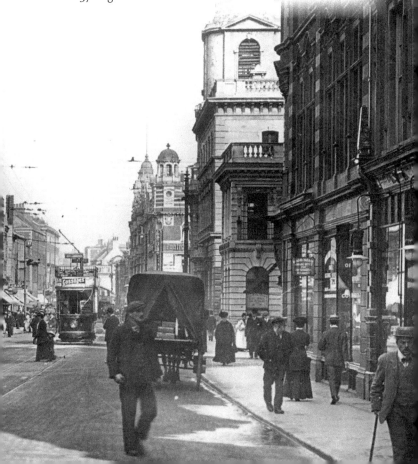

13. HIGH STREET LOOKING SOUTH

The old view is from a stereoscopic card and probably dates from the early 1920s. The shops on the right include Johnson Brothers (dyers), Frederick Cooper (hairdresser), William Rayner (furrier), and Smith & Andrews (dentists). By the mid-1990s this was a radically different scene and old traditional shops have been replaced by national chain stores. But even national names can disappear and Woolworths are now no longer a feature of the British high street.

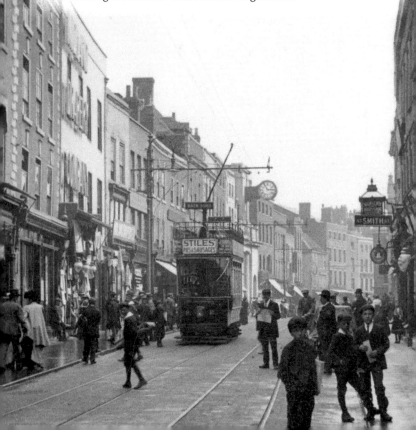

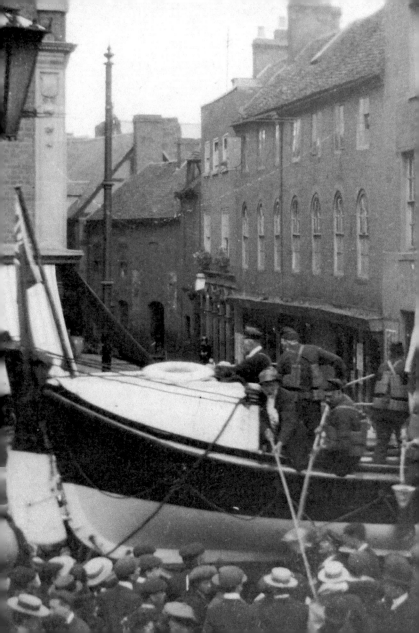

14. LIFEBOAT SATURDAY

For many years Worcester held an annual lifeboat procession, and this one features the Weston-super-Mare lifeboat and crew in 1905. In the background, at the junction of High Street with Church Street, is the music shop belonging to Edward Spark. The buildings visible in Church Street housed the well-known stationers and printers, Deighton & Co., and also another long-lost public house, the City Arms. Barclays Bank now stands close to the site occupied by Edward Spark (demolished for widening of the High Street). Church Street is now bereft of older historic buildings with the exception of the church itself.

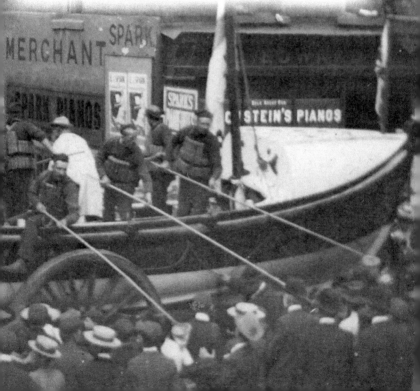

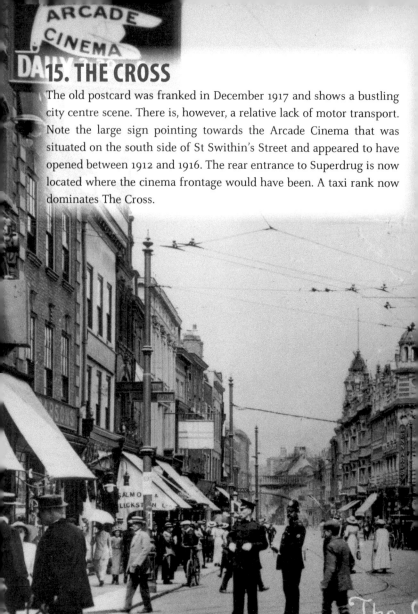

15. THE CROSS

The old postcard was franked in December 1917 and shows a bustling city centre scene. There is, however, a relative lack of motor transport. Note the large sign pointing towards the Arcade Cinema that was situated on the south side of St Swithin's Street and appeared to have opened between 1912 and 1916. The rear entrance to Superdrug is now located where the cinema frontage would have been. A taxi rank now dominates The Cross.

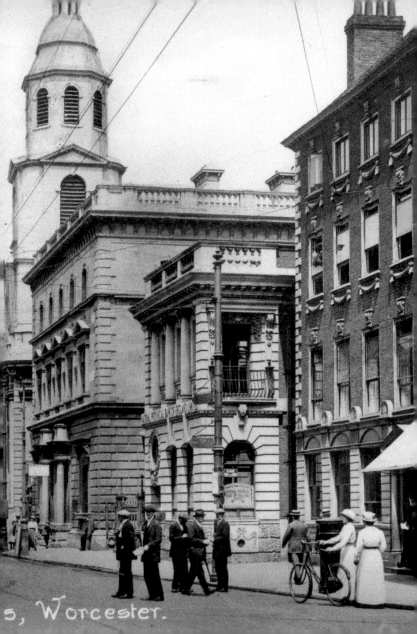

5, Worcester.

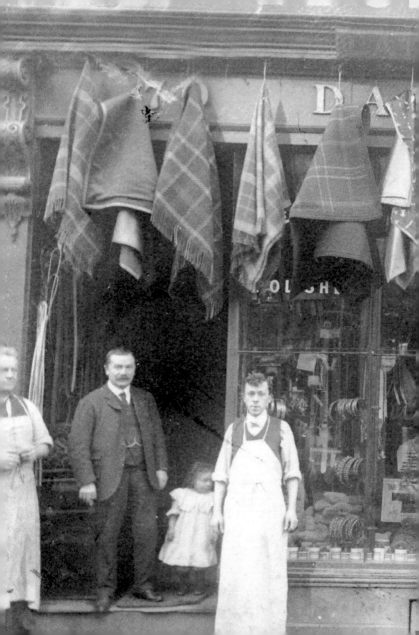

16. BROAD STREET SHOP

Aaron Sillitoe, saddler and harness maker, was situated at No. 70 Broad Street. He is pictured with his staff around 1906. Gents' and ladies' riding saddles were made on the premises and Sillitoe boasted the largest stock of saddlery in the city. However, Sillitoe had disappeared from the local directories by 1916. This building is adjacent to the Nationwide Building Society.

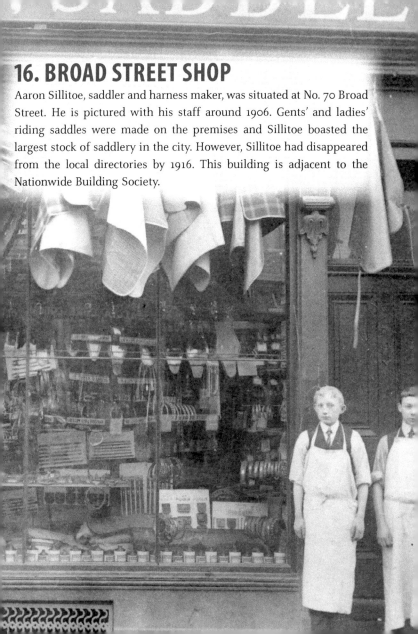

17. SHAMBLES IRONMONGER'S

Although the old postcard was franked in 1909, the photograph would appear to be late Victorian. J. & F. Hall were well-known local ironmongers and were in business at this location prior to 1840. The building itself was probably built around 1600. Its demolition, in the mid-1960s, has to be viewed as an unforgivable act of civic vandalism. Today St Swithun's church has a far less interesting neighbour.

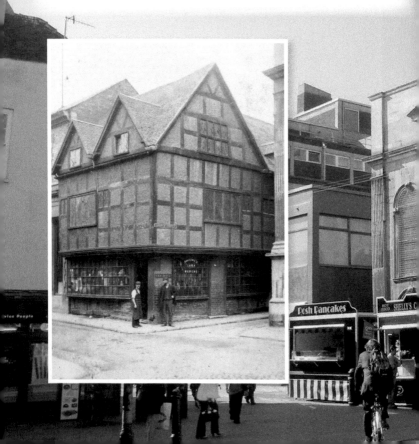

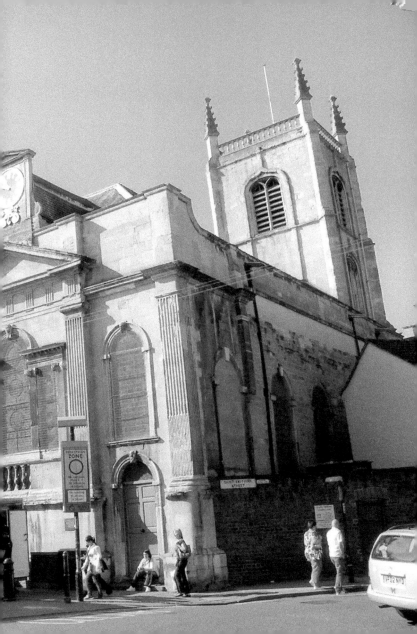

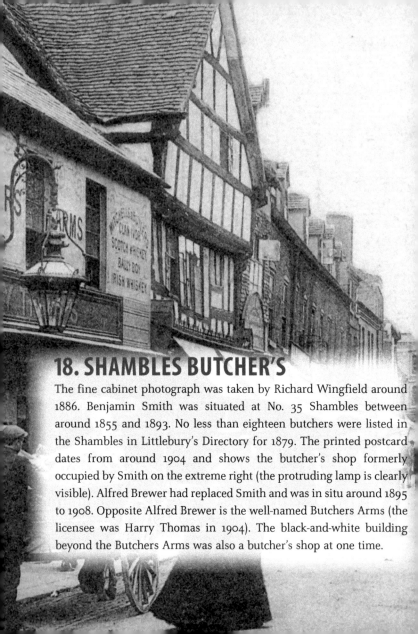

18. SHAMBLES BUTCHER'S

The fine cabinet photograph was taken by Richard Wingfield around 1886. Benjamin Smith was situated at No. 35 Shambles between around 1855 and 1893. No less than eighteen butchers were listed in the Shambles in Littlebury's Directory for 1879. The printed postcard dates from around 1904 and shows the butcher's shop formerly occupied by Smith on the extreme right (the protruding lamp is clearly visible). Alfred Brewer had replaced Smith and was in situ around 1895 to 1908. Opposite Alfred Brewer is the well-named Butchers Arms (the licensee was Harry Thomas in 1904). The black-and-white building beyond the Butchers Arms was also a butcher's shop at one time.

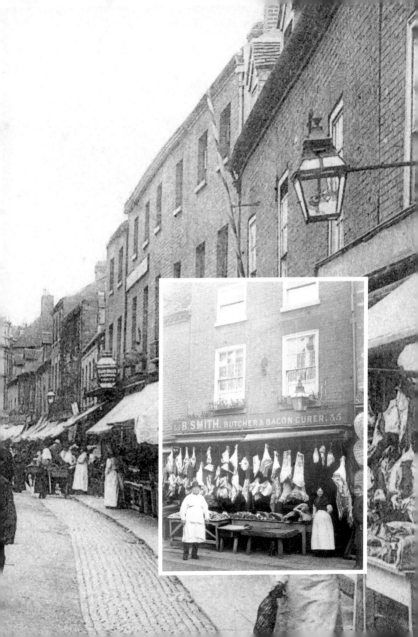

19. SHAMBLES

Sigley's China Stores were based at No. 96 High Street but also had an extensive display of goods within the Market Hall. Albert A. Preece was the proprietor and he was an agent for Royal Worcester. They boasted of supplying innkeepers upon the most moderate of terms. The postcard was used by Sigley's in 1907 in order to inform a customer in Evesham of the despatch of their order via the Midland Railway. The Shambles nowadays is rather living up to its name. It is an incongruous mixture of the old, the new and the nondescript.

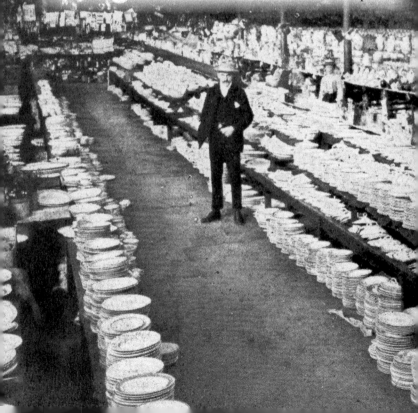

20. ST SWITHIN'S STREET BUTCHERS

The northern side of St Swithin's Street was demolished in the late Victorian period (due to road widening) and replaced with the contemporary terrace of buildings. W. Stiles were situated on the northern side of St Swithin's Street close to the junction with The Cross. Stiles were at this location between at least 1896 and 1912. They were supplied by Alfred Bevan Purnell, who farmed at Warndon Court Farm and Trotshill Farm. A thriving butchers can still be found in St Swithin's Street.

STILES

Stiles

Stiles

PIGS ARE FED UP
FOR STILE'S PIES
AND SAUSAGES

WORCESTE
PIES & SAUSAGES

ABP

21. CORN MARKET

This was the principal market place for grain for several centuries. In 1840, this was described as a large, nearly square area hosting a weekly market on Saturday afternoons. On the right of the engraving is the Corn Exchange building. This was demolished in 1845 and replaced by the public hall (built in 1848/49 and demolished in 1966). This location then became a car park. Back in 1981, the Worcester Market moved from the old Sheep Market to the Corn Market car park. It operated on Fridays and Saturdays and included my own pet stall.

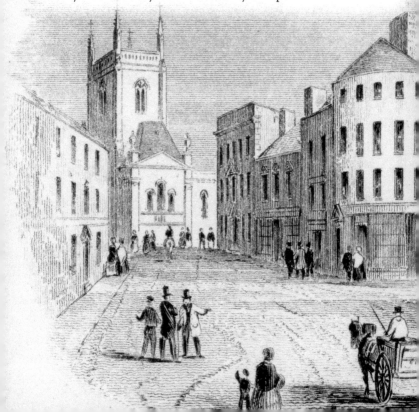

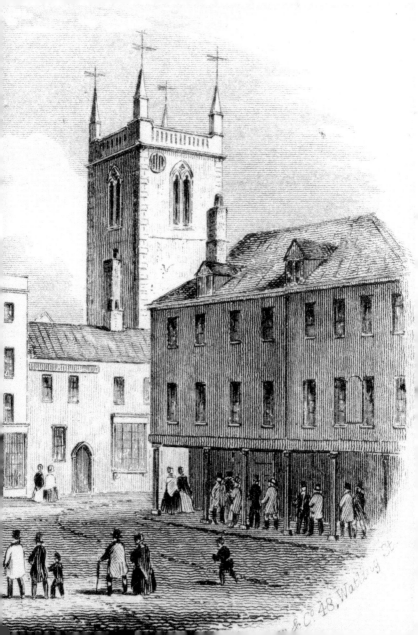

&Co 48, Watling St.

22. CORN MARKET CORN MERCHANT

J. W. Holtham & Co., established in 1801, was another well-known local business. Their trading name was continually used by subsequent owners until a more recent change of use. The old postcard view was franked in 1907. The writer was Mr Preece, the then owner, who was going to Weston-super-Mare for his August holiday. The frontage of the shop looks basically the same today. New Street still maintains a largely traditional and historic environment.

23. CORN MARKET

Old St Martin's, completed in 1772 at a cost of £2,215, is a beautiful church and well worth a visit. The stained-glass windows are particularly fine. The Corn Market today is a busy location and the public houses seem to be thriving. Fortunately, this remains a location of largely historic and interesting buildings. If the open-air car park could be replaced with a development of merit then the Corn Market could be improved still further.

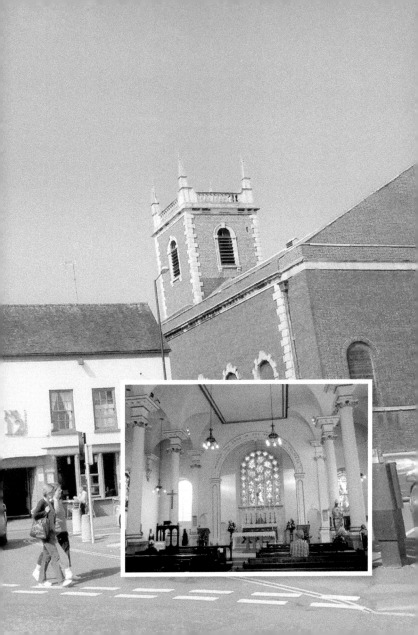

24. SILVER STREET INFIRMARY

Whiteman & Co., ironmongers and cycle agents, pictured around 1904 at Nos 40/41 Silver Street (by 1908 renumbering had taken place and the address became Nos 18/20 Silver Street). Whiteman's were still listed at this location in the local trade directory for 1955/56. In recent years this has been a Majestic Wine warehouse. These premises housed Worcester's first infirmary for around twenty-five years from 1745. They will thankfully be refurbished as part of the current Lowesmoor redevelopment scheme.

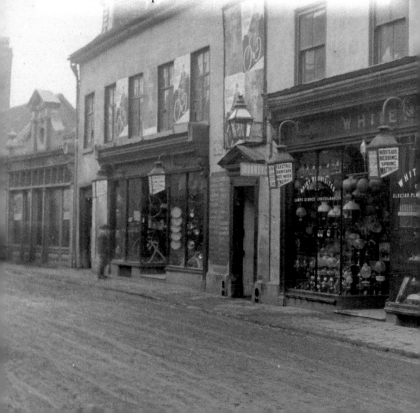

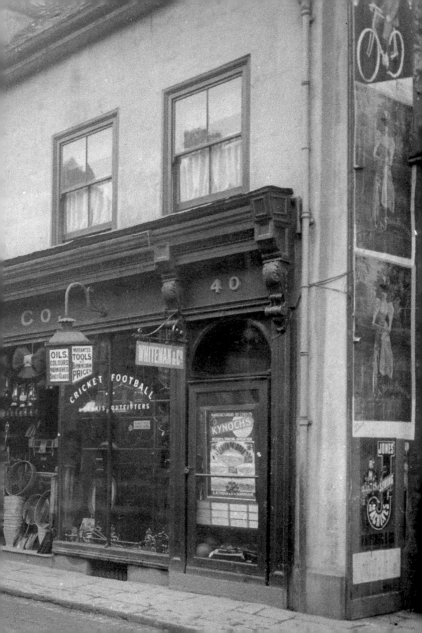

OILS.
COLOURS
VARNISHES
SHEET GLASS

WARRANTED
TOOLS
OF EVERY
DESCRIPTION
PRICES

CO

40

WHITEMAN & C

CRICKET FOOTBALL

& OUTFITTERS

MANUFACTURERS OF CLOTH TO
KYNOCHS

& STROUD & CO., BIRMINGHAM

JONES
CYCLES STRONG

25. GREAT FILLING HALL IN 1993

When this historically important building was built it had, reputedly, the world's largest single span roof (the dimensions are certainly impressive as the hall measures 160 feet by 120 feet with a height of 70 feet). Underwoods, the well-known local firm, used the building as a steel stockholding facility for a number of years. Thankfully the Filling Hall is now fully restored to its former glory and is the new headquarters for the Territorial Army.

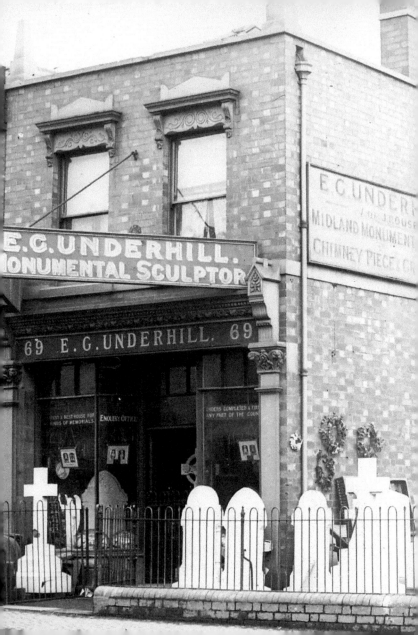

26. LOWESMOOR PLACE

Edmund George Underhill was in business here for many years but had a perhaps unlikely neighbour in the West Midland Tavern that still survives today. The old postcard (franked in 1907) was personally written by Mr Underhill in the course of his business.

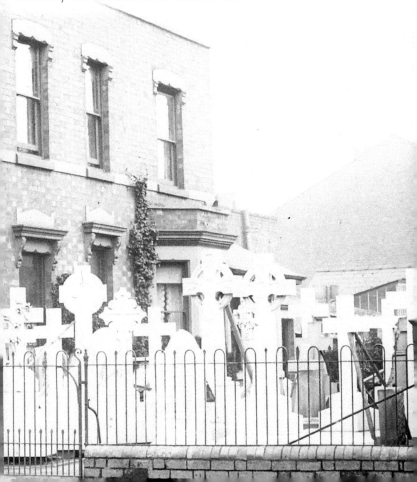

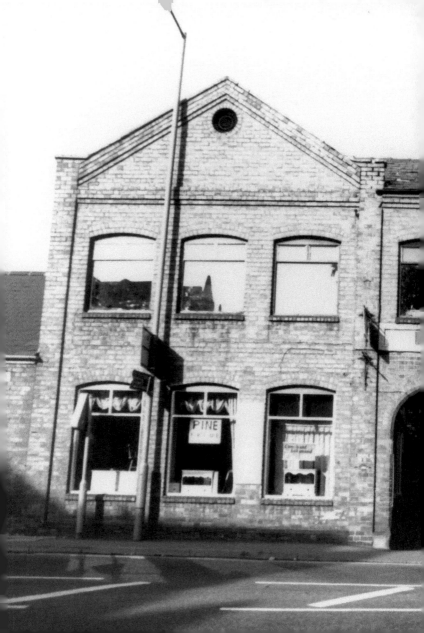

27. KILN REVEALED

Considering that Worcester is world famous for porcelain, it is rather disappointing that there is not one intact bottle kiln remaining. However, the demolition of old premises in Lowesmoor has led to a renewed sighting of the partial remains of a bottle kiln. This was sited within the Grainger Works that was taken over by Royal Worcester in 1889. Grainger's had been in the area since around 1808, but a fire had destroyed their original works in 1809 and they had to build new works on this site, which adjoined the vast vinegar works complex. The older photograph shows the frontage of the Grainger factory in 1993. A part of the bottle kiln is now preserved within the new shopping complex.

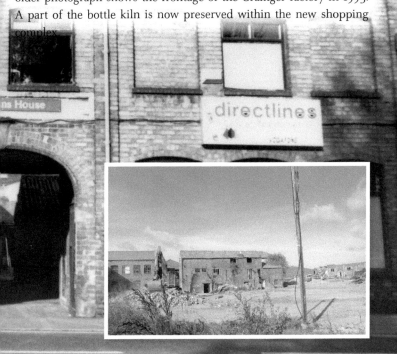

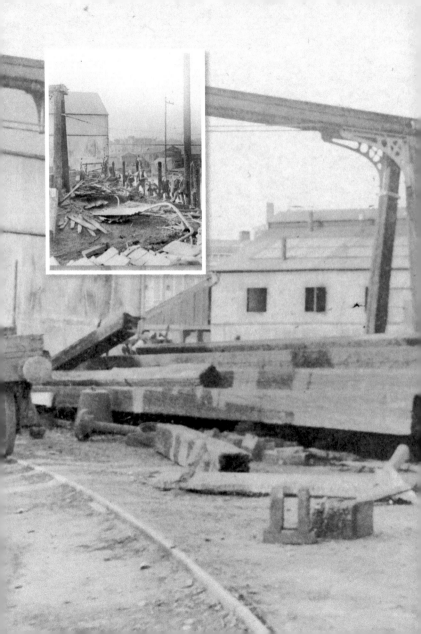

28. VULCAN WORKS

The firm of McKenzie & Holland, railway signal engineers founded in 1862, were based at the works that occupied an area of around 4 acres (situated on both sides of the Birmingham and Worcester Canal). In 1897, the firm boasted that it was the largest industrial institution in Worcester and employed over 600 workers. The two old views appear to depict the aftermath of a fire from around 1910. This part of the site is still in industrial use today. Cromwell Street is now a characterless cul-de-sac.

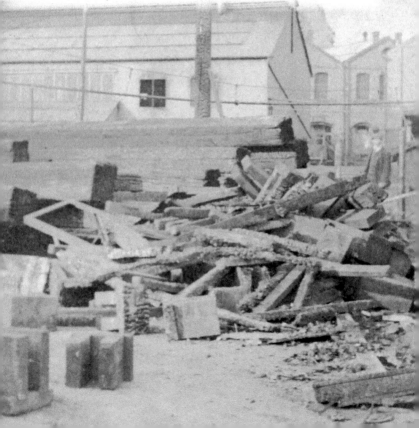

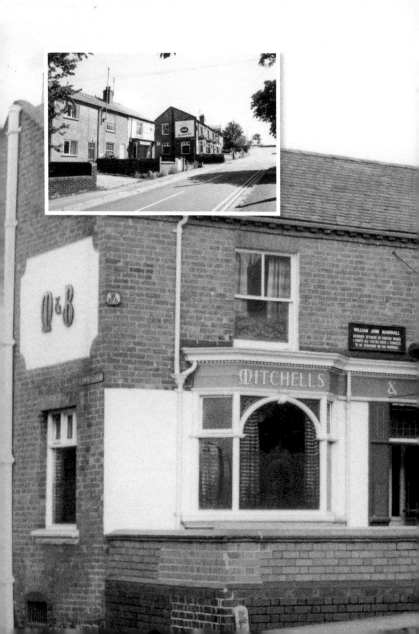

29. HILL STREET BLUES

Back in 2001, in *Worcester Past and Present*, I commented that the Beehive, located on the corner of Tallow Hill and Hill Street, faced an uncertain future. There was some hope that it might have formed part of the new retail park development, but that hope was forlorn. William John Marshall was licensee in the photograph taken around 1960. The Beehive had changed only slightly by 2001 and appeared to be thriving. Interestingly the only building surviving from the 2001 view is Elgar House. This unattractive edifice is regularly voted Worcester's most hated building.

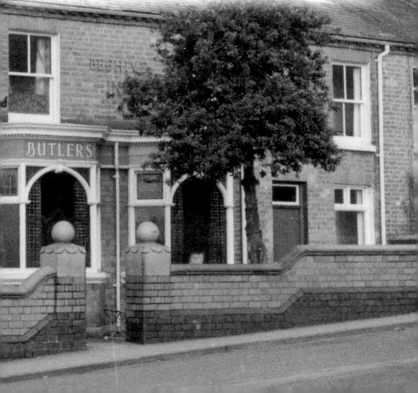

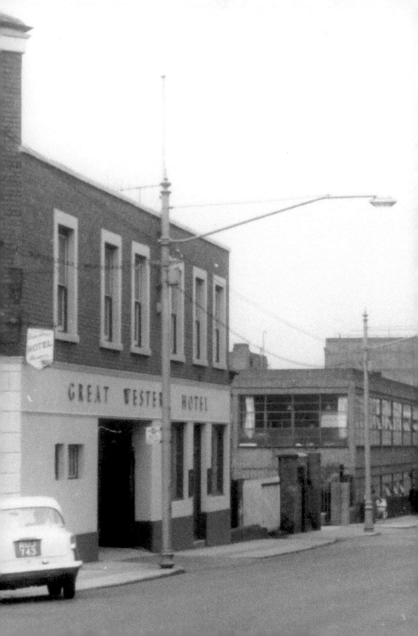

30. GREAT WESTERN HOTEL

The photograph from 1960 shows where the 'Vinegar Line' crossed the Shrub Hill Road. Beyond the Great Western Hotel, on the southern side of the Shrub Hill Road, can be seen engineering works located on the site of the old Vulcan Works. The Great Western Hotel survives today but all of its rivals have long gone; they include the Ram Tavern, the Railway Arms, the Prince of Wales, Crowle House and the Beehive.

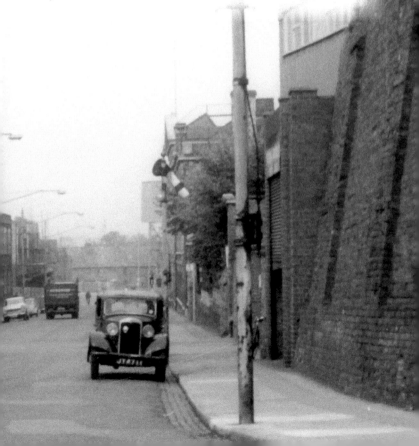

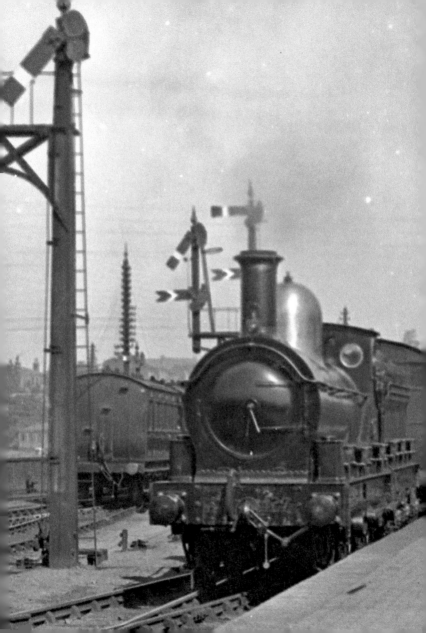

31. SHRUB HILL STATION

On the extreme left of this probably Edwardian view can be seen a tank engine en route for Bromyard. The main engine to be seen is No. 427, an 0-6-0 outside frame tender engine built in 1868 at the GWR workshops in Swindon, and withdrawn from service in 1917. Trains these days lack the romance of former days, I am afraid. In the far distance can be seen the white frontages of the impressive houses on Rainbow Hill Terrace.

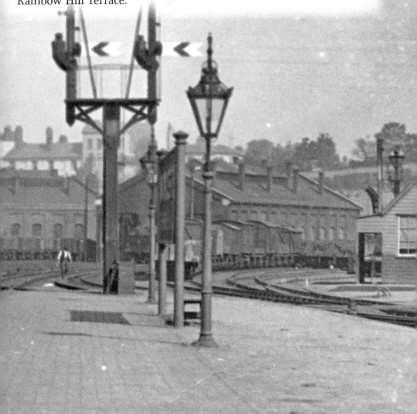

32. SHRUB HILL SHED

Worcester was a major locomotive shed for many years and had the code of 85A. This view, taken from Railway Walk, shows the council houses of Rose Avenue in the background. Steam locomotives were allocated to Worcester until the end of 1965, although steam locomotives from other sheds continued to be seen at Worcester for some months after that. The railway operations at Shrub Hill covered a large area and initially included large engine construction works. Other forms of industry have now replaced and eradicated Worcester's glorious railway past.

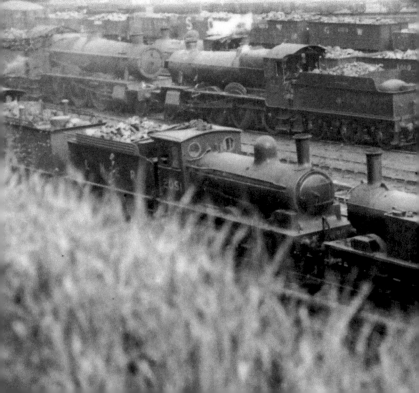

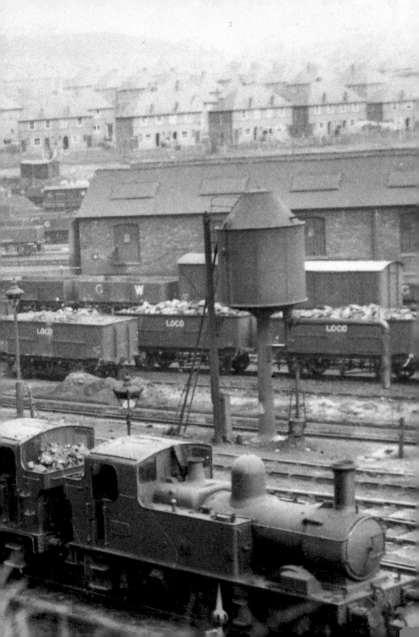

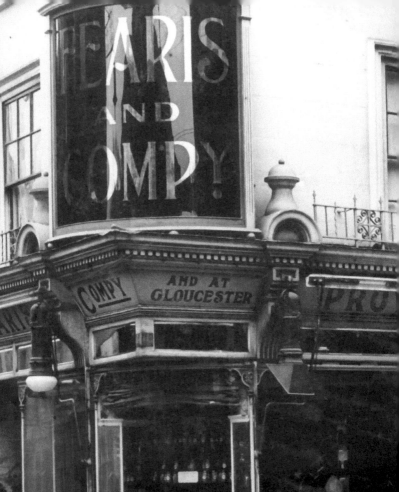

33. FOREGATE STREET SHOP

The business of Fearis & Co. was located in the Foregate, at the junction with Angel Street. It would appear that they moved from premises in Mealcheapen Street around 1919. This edifice was an important part of the essentially Georgian line of buildings that extends from the top end of the High Street to The Tything. Why it was allowed to be demolished is a complete mystery to me. Perhaps one day a suitable edifice may be erected at this important location.

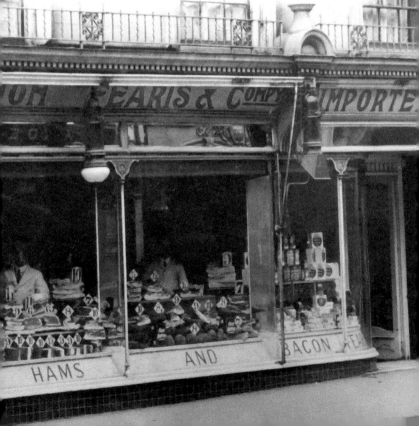

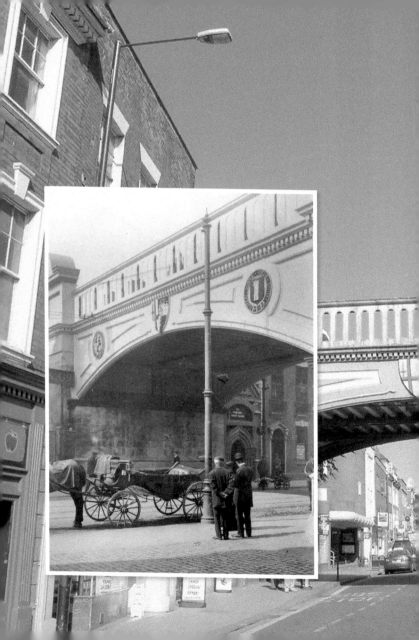

34. FOREGATE STREET BRIDGE

The old view is by Percy Parsons and features cab no. 33. There is a fairly intact Georgian linear development on the western side of Foregate Street. Unfortunately, the building of the Odeon cinema, which opened in 1950, resulted in the demolition of the Silver cinema that had been sited within a building constructed in 1835. Thus a new building, in modern streamlined style, came to share Foregate Street with traditional Georgian neighbours.

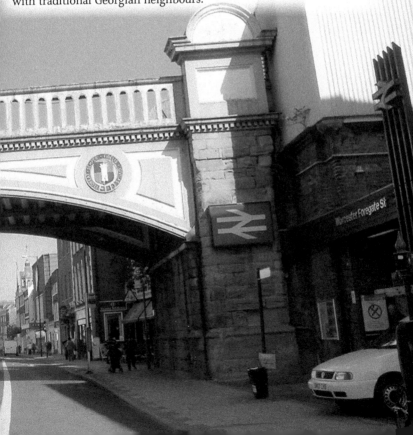

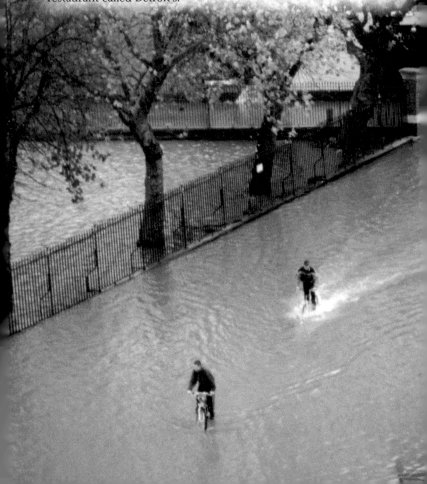

35. CASTLE STREET CHANGE

The car showrooms largely escaped the effects of the flood of 2 November 2000, but did eventually become a victim of economic recession. This prime site is currently home to an American dining restaurant called Detroit's.

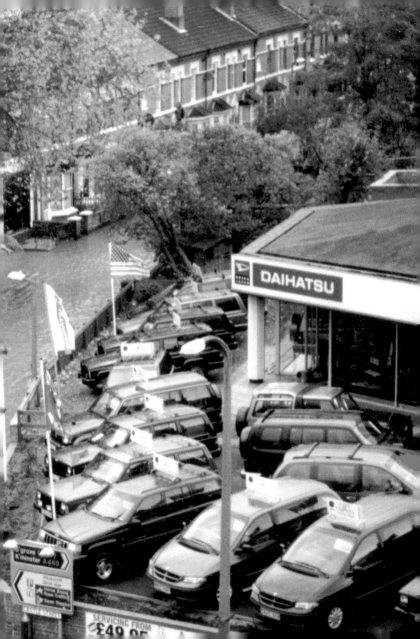

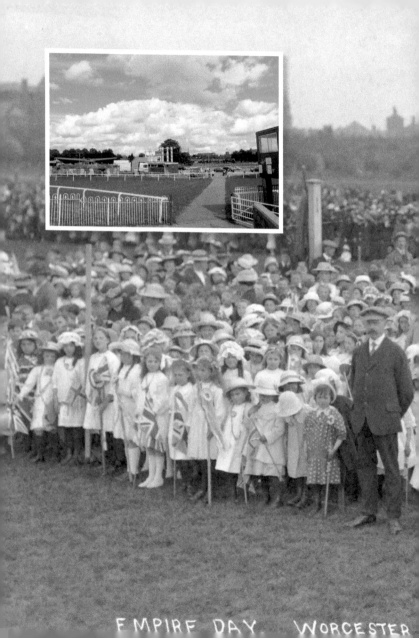

EMPIRE DAY. WORCESTER

36. PITCHCROFT

In the early twentieth century, many events were traditionally staged at Pitchcroft. The old photograph features Empire Day in 1917. In the top left background, the outline of the city gaol is just discernible.

17. No. 6.

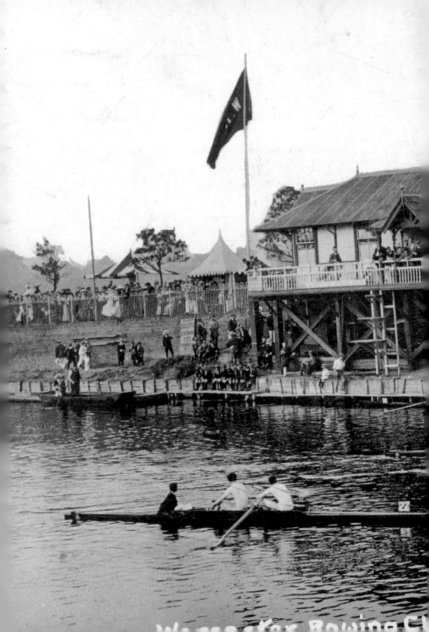

Worcester Rowing Cl

37. ROWING CLUB, PITCHCROFT

Worcester Rowing Club was formed in 1874, but there were many other clubs before this date and organised rowing races were arranged over 200 years ago. The old postcard was franked in 1915 and also shows the rear of the grandstand. The late nineteenth-century timber clubhouse was severely damaged by fire following an arson attack in the spring of 1996. However, it has been rebuilt in the same basic form and was adapted for use as a fitness centre. The Worcester Rowing Club possesses large and impressive facilities close by.

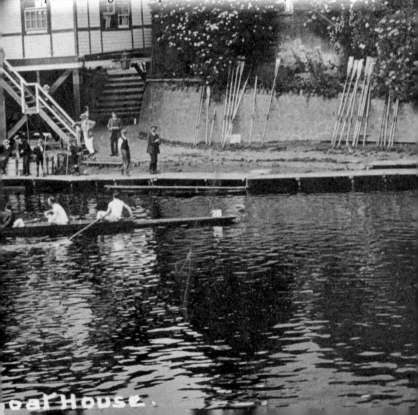

oaf House.

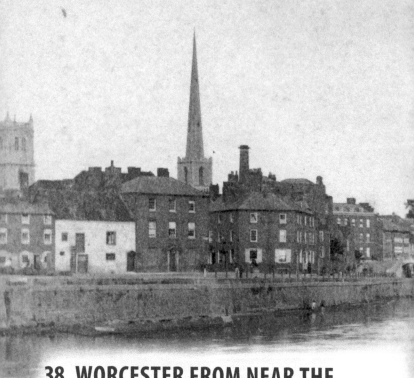

38. WORCESTER FROM NEAR THE RAILWAY BRIDGE, HYLTON ROAD

The old view is from a stereoscopic card by Francis Earl that would appear to date back to at least the 1860s. The 'Butts Spur' railway line that followed the line of the river not only served North Quay but also South Quay, via a short tunnel underneath the railway bridge. South Quay was then a bustling area of industrial and commercial activity. North Quay has also changed significantly since then, with attractive old buildings no longer being part of the view.

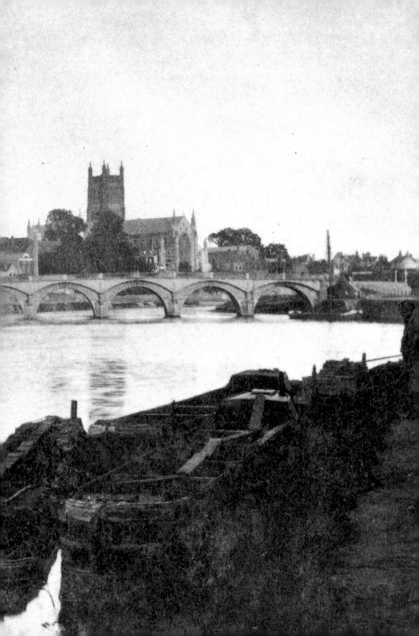

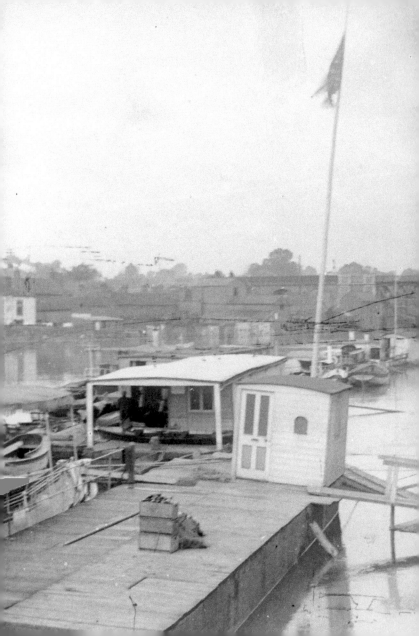

39. NORTH QUAY AND NORTH PARADE IN FLOOD

In the photograph the Hope and Anchor public house (in Newport Street) can be seen behind the Old Rectifying House. This might be the flood of December 1910. The Old Rectifying House appears frequently in flood photographs of Worcester and always seems to be teetering on the edge of potential devastation at the time of the flood. The 'Butts Spur' railway line can be clearly seen.

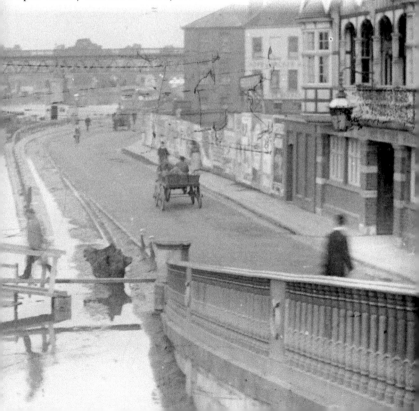

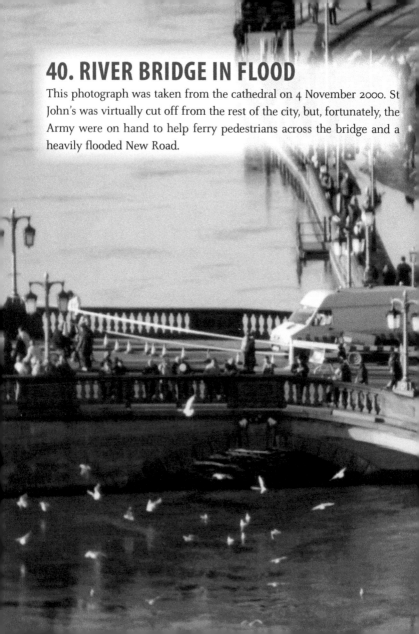

40. RIVER BRIDGE IN FLOOD

This photograph was taken from the cathedral on 4 November 2000. St John's was virtually cut off from the rest of the city, but, fortunately, the Army were on hand to help ferry pedestrians across the bridge and a heavily flooded New Road.

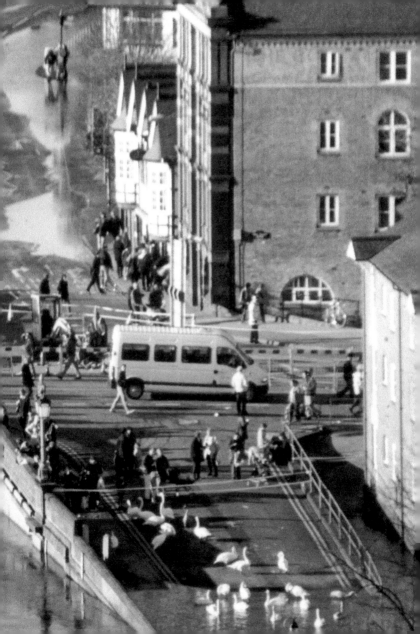

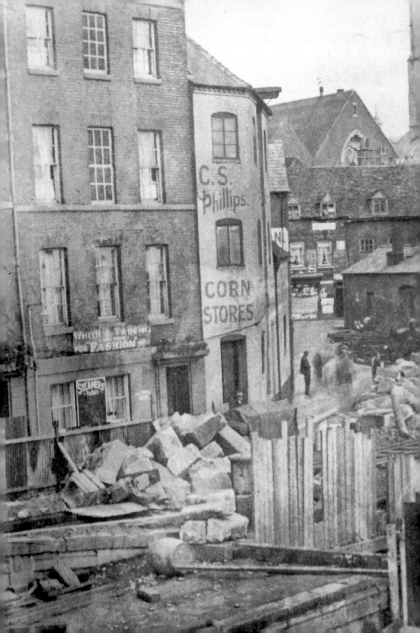

41. SOUTH QUAY AND THE CATHEDRAL

This view is from 1930 and shows the busy and chaotic scene as the scheme to widen the bridge took place. In the middle foreground is Hood Street that leads to Quay Street.

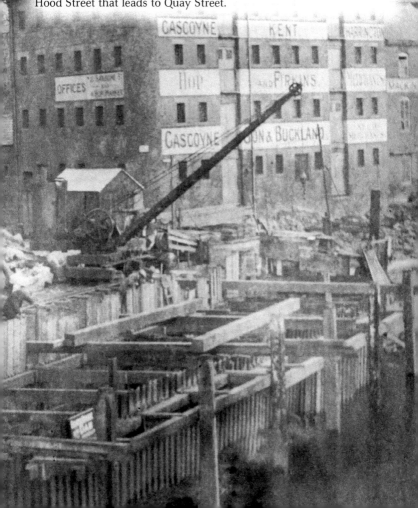

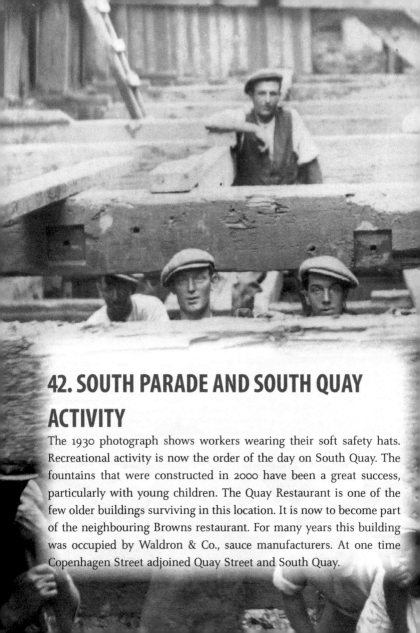

42. SOUTH PARADE AND SOUTH QUAY ACTIVITY

The 1930 photograph shows workers wearing their soft safety hats. Recreational activity is now the order of the day on South Quay. The fountains that were constructed in 2000 have been a great success, particularly with young children. The Quay Restaurant is one of the few older buildings surviving in this location. It is now to become part of the neighbouring Browns restaurant. For many years this building was occupied by Waldron & Co., sauce manufacturers. At one time Copenhagen Street adjoined Quay Street and South Quay.

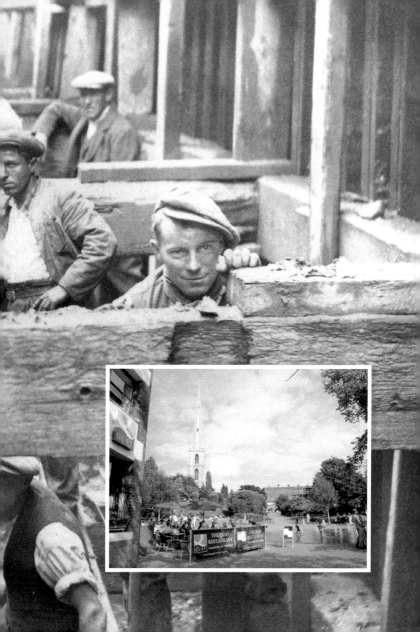

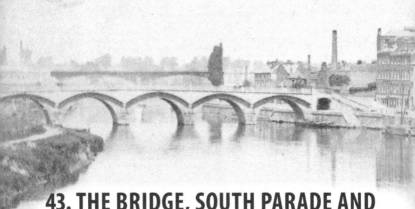

43. THE BRIDGE, SOUTH PARADE AND SOUTH QUAY FROM THE SOUTH

The larger view is from a stereoscopic card by Francis Earl that would appear to date back to at least the 1860s. There is a curious lack of activity on South Quay that suggests Earl took the photograph very early in the day or maybe on a Sunday. South Quay has totally changed from an area of commerce to an area for tourism. In the inset view of the quay, numerous carts can be seen on the quayside, and the photograph dates back to at least the 1860s.

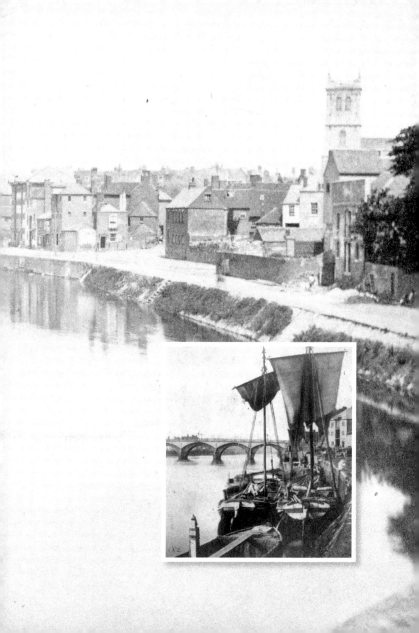

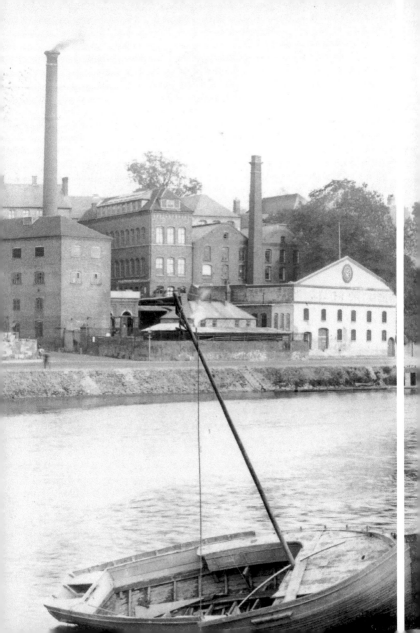

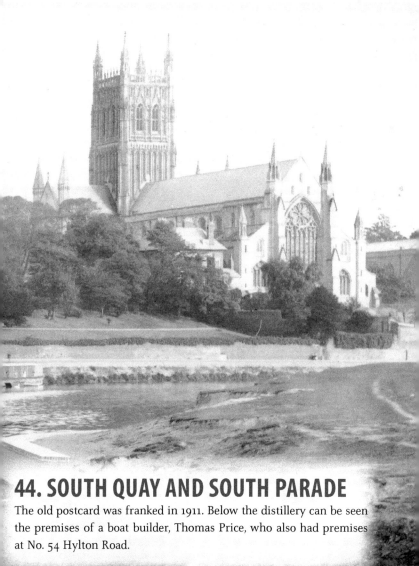

44. SOUTH QUAY AND SOUTH PARADE

The old postcard was franked in 1911. Below the distillery can be seen the premises of a boat builder, Thomas Price, who also had premises at No. 54 Hylton Road.

ABOUT THE AUTHOR

Ray Jones is a local businessman and historian who was born in the city of Worcester. Educated at St Stephen's School, Worcester and the Worcester Royal Grammar School, he then obtained a BA in Geography at the University of London. He has written and published several books about Worcester and the surrounding area, including his very successful *Worcester Through Time*. Ray has also carried out extensive research into both local history and the origins of Worcester porcelain. He wrote an important article on Lund's Bristol porcelain for the Northern Ceramic Society Journal in March 2007, and is the author of *Worcester Porcelain - An Illustrated Social History*.

He is currently writing an extensive book on the origins of Worcester porcelain that is scheduled for publication in late 2015.